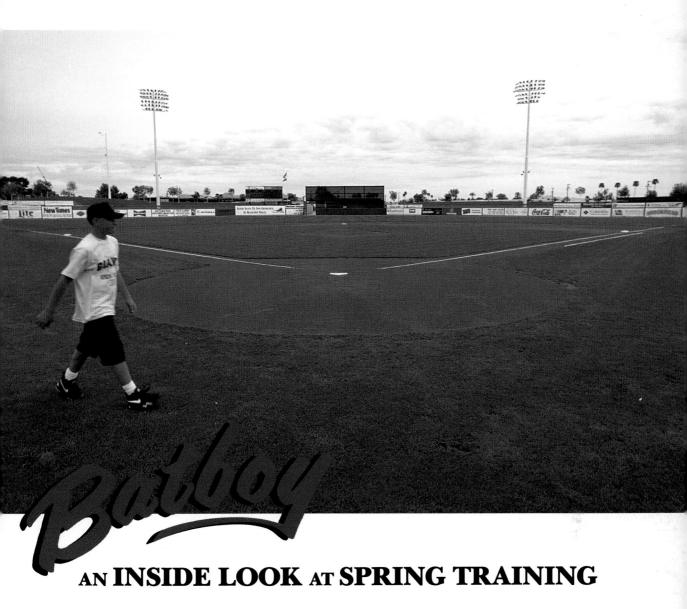

Batboy

AN **INSIDE LOOK** AT **SPRING TRAINING**

by **Joan Anderson**

photographs by **Matthew Cavanaugh**

Lodestar Books
Dutton New York

Acknowledgments
We are most grateful for the hospitality shown to us by the San Francisco Giants organization. Thanks to Robin Carr in public relations, Mike Murphy and Dave Rosen in the clubhouse, and many of the players, especially Matt Williams, Kirt Manwaring, Rex Hudler, Robby Thompson, and Fred Costello, for answering our questions. We appreciate Roy Garibaldi's advice and instruction. Of course, the entire book would not have been possible without Kenny Garibaldi. Thanks for allowing us into your world.

Special thanks to my friend Mike La Coss, who introduced me to spring training and helped with the structure of the entire project.

Text copyright © 1996 by Joan Anderson
Photographs copyright © 1996 by Matthew Cavanaugh

Library of Congress Cataloging-in-Publication Data

Anderson, Joan.
 Batboy / by Joan Anderson; photographs by Matthew Cavanaugh.
 p. cm.
 ISBN 0-525-67511-6 (alk. paper)
 1. Bat boys—Arizona—Juvenile literature. 2. Spring training (Baseball)—Arizona—Juvenile literature. I. Cavanaugh, Matthew.
II. Title. 95-11793
GV867.5.A53 1996 CIP
796.357′64′09791—dc20 AC

Published in the United States by Lodestar Books,
an affiliate of Dutton Children's Books,
a division of Penguin Books USA Inc.,
375 Hudson Street, New York, New York 10014

Published simultaneously in Canada
by McClelland & Stewart, Toronto

Editor: Rosemary Brosnan Designer: Barbara Powderly
Printed in Hong Kong First Edition 10 9 8 7 6 5 4 3 2 1

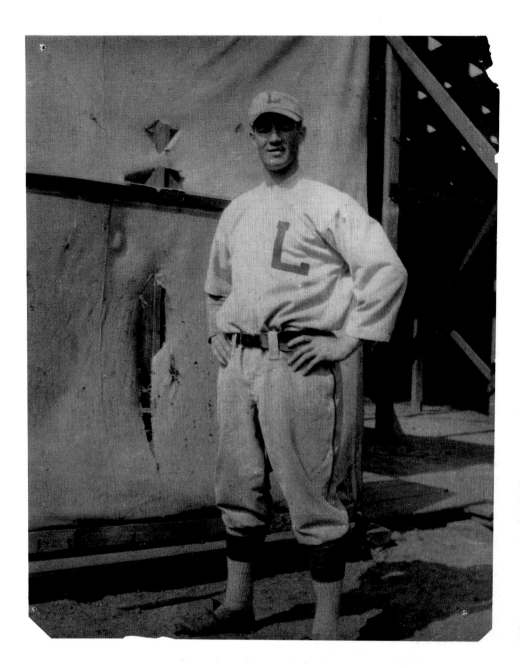

to the memory of my grandfather,
Charles Reynolds Snyder,
pitcher for the St. Louis Browns

J.A.

for Barry Donahue,
teacher and friend

M.C.

Introduction

Very few people get as close to the game of baseball as the batboys. They see it all—in the clubhouse, in the dugout, and on the field. Batboys become part of the pulse of the game, working alongside players, coaches, and managers.

To the players, they are like little brothers. They provide comic relief and are very often victims of clubhouse pranks. Sometimes a player becomes closer to one boy than another. The player might sit beside a batboy on the bus going to an away game and strike up a friendship. Or a batboy might go out of his way to do something special that the player doesn't forget.

When I got to the big leagues, everything was new and exciting. I was so focused on my playing that I hardly noticed what went on around me. It took a while to realize that the batboy who would hand me a batting glove or a pine tar rag when I was on deck was the same boy who, a couple of hours before, was straightening up the locker room and doing my laundry. When it sank in, I was amazed at how long this boy had been at the stadium and how late he would be staying that night.

It's a tough job. Players are always telling batboys to do this or do that. They must learn to hustle. I suppose you could say that batboys help players *do* the game. The game is the stage, and the batboy is part of the stage crew. If he is really good, he will anticipate the action—running after bats that are thrown aside, noticing when the umpire is out of balls. The good batboys can speed up the game, and that's what everyone wants. You can't do the job if you are lazy. You've got to love the game, be a fast learner, and have a lot of common sense.

Being a batboy is a great way to get a job in professional ball, either behind the scenes or on the field. It's a good training ground because batboys see it all. One former batboy with the Houston Astros is now their traveling secretary. Another is visiting clubhouse manager for the Chicago Cubs.

I hear that Kenny Garibaldi hopes to be a catcher. Working spring training and then for the Giants' farm team is giving him the chance to achieve his goal.

Mike LaCoss, Pitcher
National League Champion, 1989, San Francisco Giants
Western Division Champion, 1987, San Francisco Giants
Western Division Champion, 1979, Cincinnati Reds

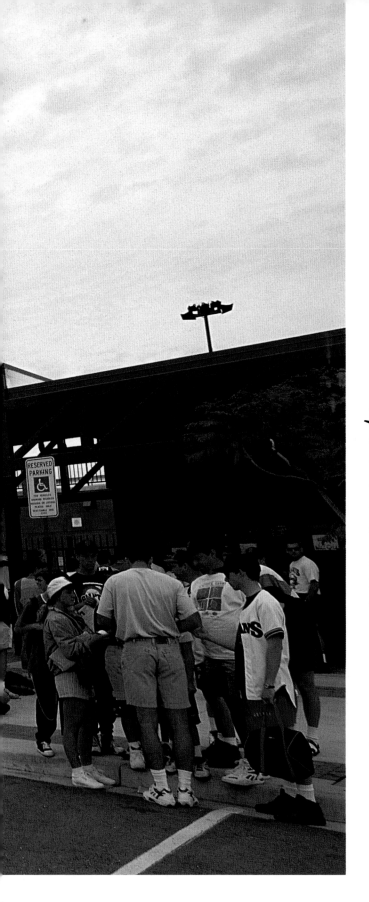

*I*t is early morning at the adobe-colored stadium in Scottsdale, Arizona—spring-training grounds for the San Francisco Giants. Although opening day is still weeks away, baseball fever is heating up. The familiar smells of freshly cut grass, hot dogs grilling, peanuts, and popcorn fill the air. Long lines of baseball fans wait for the ticket booth to open up, while eager kids stand at the curbside, pens in hand, hoping to catch a player as he arrives for the day.

At eight o'clock, a black truck pulls into the parking lot and out jumps a well-built, blue-jean-clad player and a young man.

"That's Kirt Manwaring!" someone shouts, running to greet him. "Mr. Manwaring! Mr. Manwaring! May I have your autograph?"

A gruff-looking Manwaring motions to a spot where he'll stop to sign while fans swarm around like bees to a hive. His companion, thirteen-year-old Kenny Garibaldi, stands like a bodyguard nearby. Kenny, a neighbor of Kirt's, drives to work with the Giants' star catcher because he is the team's batboy.

"I love being around the players," he says, "especially Kirt since he's a catcher. That's my position in Babe Ruth Baseball. I've picked up lots of tips from him. He even gave me his old knee pads and face mask."

Being a batboy is a training ground for a baseball career. "The hours are long," says Kenny, looking at his watch, anxious now to get inside the clubhouse and work. "Like today, we have a doubleheader, and I'll be here for all of it!" Fortunately it's Easter vacation and there's no school. "I'm going to work at every game during vacation," Kenny says, "and then when Easter break is over, I'll come in nights or after school to clean up."

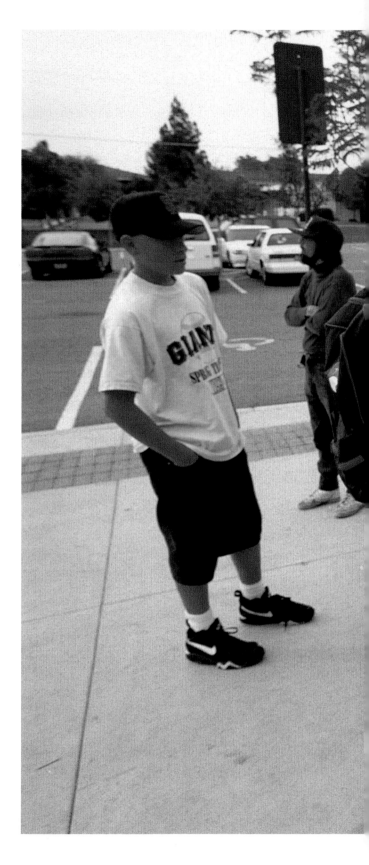

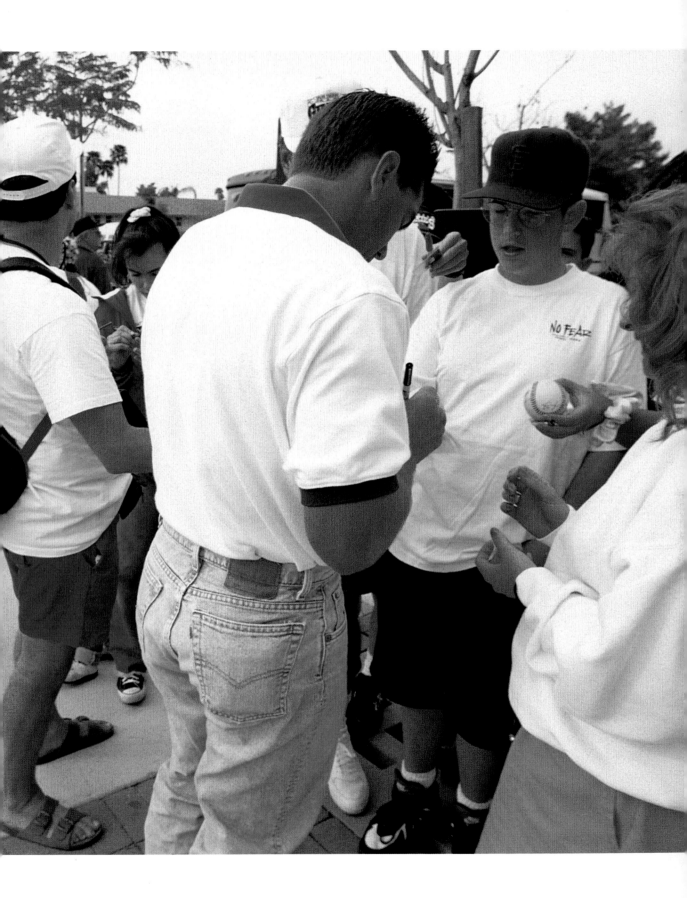

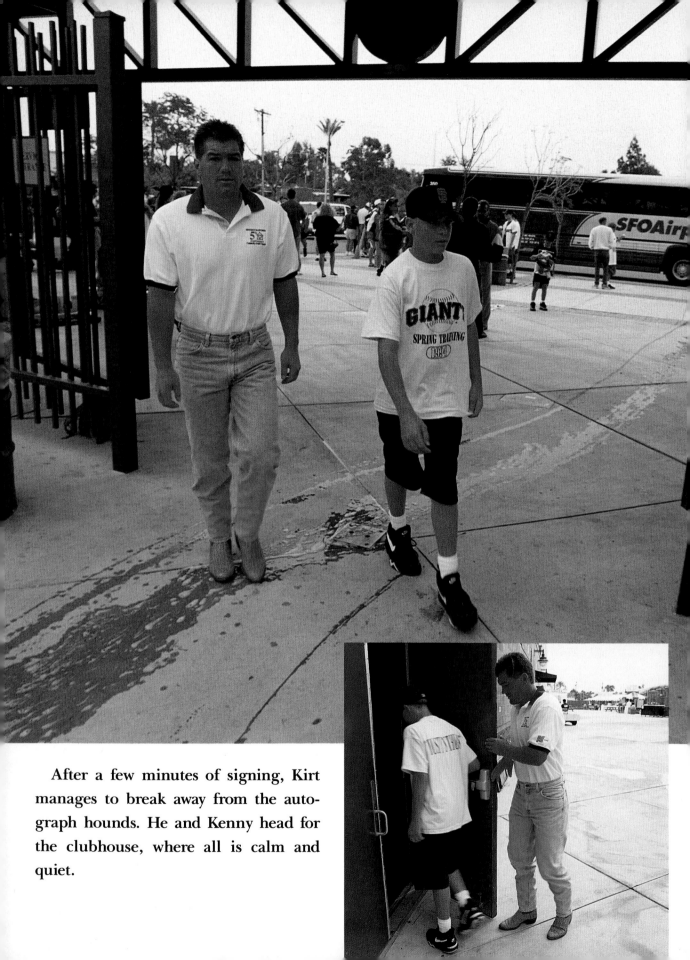

After a few minutes of signing, Kirt manages to break away from the autograph hounds. He and Kenny head for the clubhouse, where all is calm and quiet.

Kenny strolls nonchalantly, as if he is in the halls of his school, not in the midst of a major-league ball club. Mingling with players like Barry Bonds, Willie McGee, and Matt Williams is all in a day's work. "At first I couldn't believe it," Kenny says. "But now it feels pretty normal. They're just ordinary people.

"You learn to be a batboy by doing it," he says, passing by the training room, where early arrivals are getting massages or are working out on various machines. Kenny got his job because his dad was the team photographer. "A lot of kids come in here for a day or two because they know somebody," Kenny says, "but it's the real workers who last. I got to be a regular by staying around after the game and cleaning up. This isn't about hanging out in the dugout."

For the first couple of hours Kenny must hustle: sorting uniforms, delivering fan mail to lockers, answering the phone, unwrapping gum so that it is easily accessible to players on the run, even taking out the garbage.

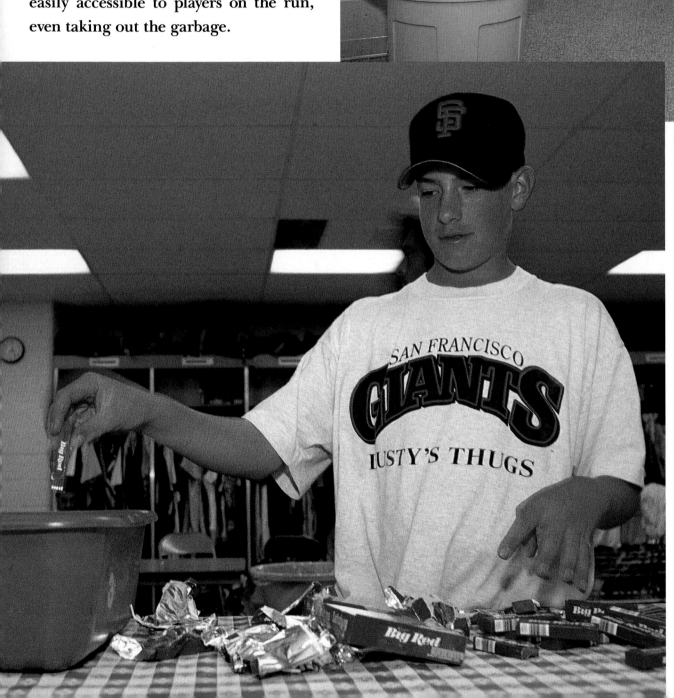

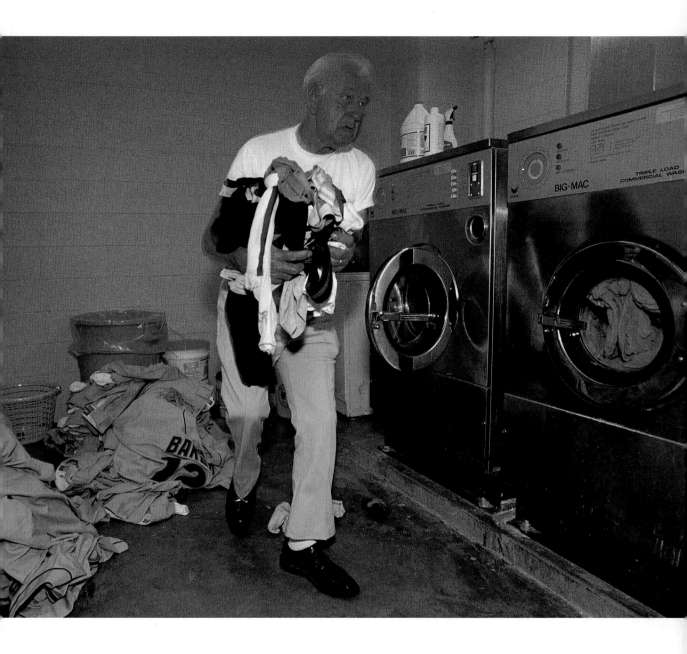

"The important thing is to make sure all the players are ready by game time," Kenny explains.

He makes endless trips to the laundry, where Pops, the man who washes the clothes, fills Kenny's grocery cart with clean socks, underwear, T-shirts, jerseys, and pants. Then Kenny hangs them in the appropriate lockers.

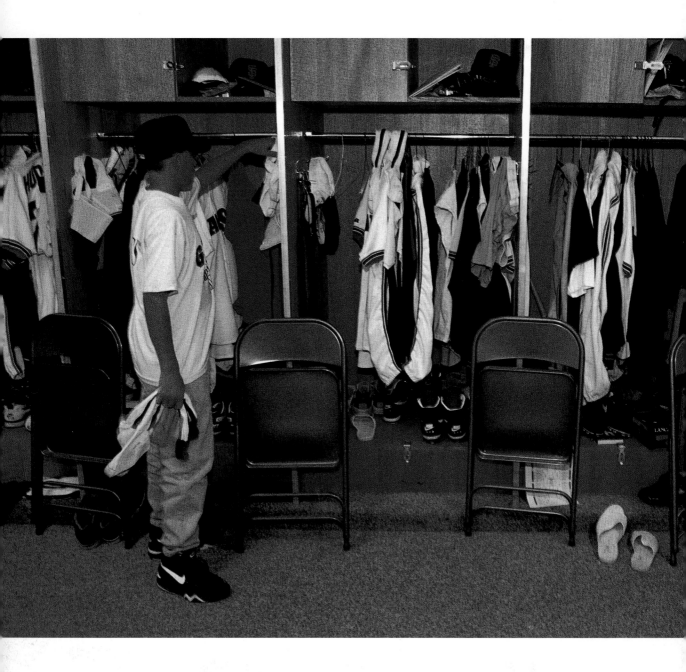

"Some of the guys are superstitious," he says. "They want their stuff a certain way. Some like their uniforms damp; others want their shoes washed, not shined; still others like their bat stashed inside their locker, not on top. It's important to learn each one's little quirks." Even the clubhouse dog needs Kenny's attention.

Kenny takes his orders from veteran clubhouse manager Mike Murphy. "I don't tell him what to do anymore," Murph says. "Kenny's a good kid. He cares for the game. You can see it in everything he does." Murph's been picking out batboys for some thirty years. Mostly they write him a letter and ask for the job. "I keep the letters on file, and when there's an opening, I call a kid up and ask him to send me his report card. If he does well in school, he'll probably be reliable in the dugout."

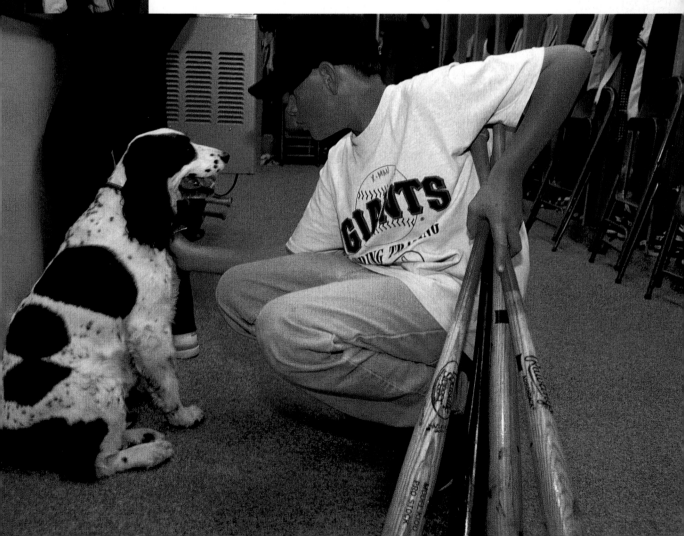

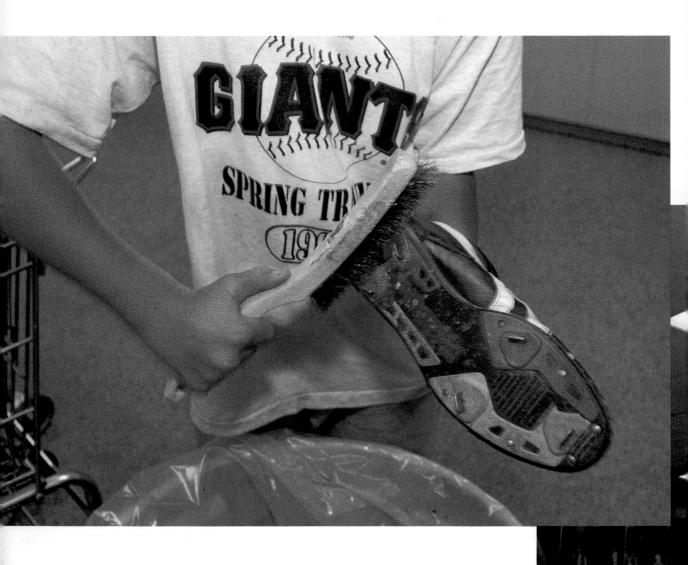

In the center of the locker room are carts piled high with shoes that are caked with grass and dirt. The shoes need brushing, washing, and polishing. It's an endless job, especially after a rainy game. "Whenever it looks like there's nothing to do," says Kenny with a dull tone in his voice, "there are always the shoes!"

While Kenny performs his pregame chores, he must duck around players who have their own anxieties. Some are fighting for their jobs; others hope to nail down a starting position; still others just want to get some playing time and hope to impress a coach or manager.

As the room fills up with the forty-three players on the spring-training roster, everyone knows that by opening day that number will dwindle to twenty-five. Although the players seem casual, even occasionally jovial, there is an edge of tension that keeps Kenny alert. He must sense what the players need and carry it out before they ask him.

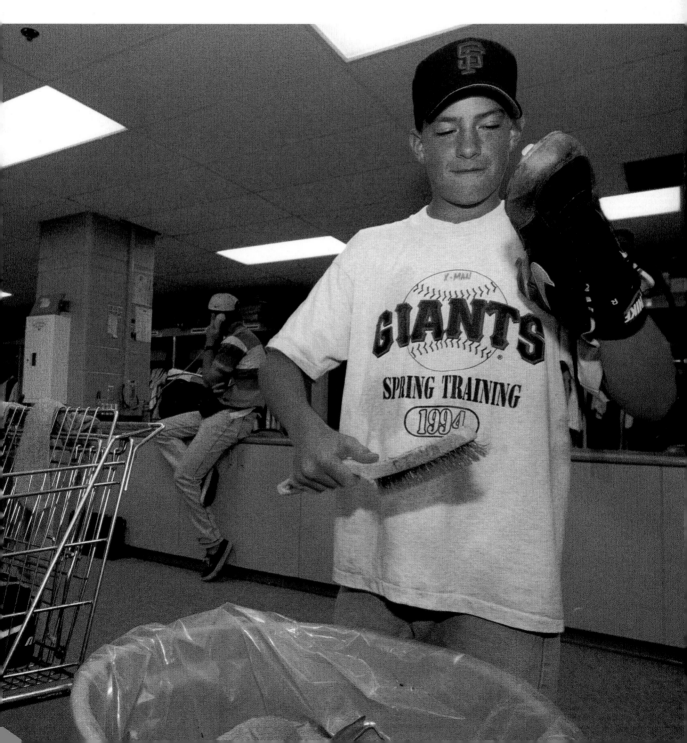

"I never talk to the players unless they speak to me," Kenny says. It's a subtle dance of being in the center of the action and yet seeming not to be there at all. "My dad told me that the players are here to do a job, not to talk to me."

Suddenly a commotion fills the hallway. A media crew is following baseball legend Joe Garagiola, who is talking about the terrible effects of chewing tobacco. He holds court in the Giants' locker room beside a former Giants center fielder, the renowned Willie Mays, who has stopped by to rally the troops.

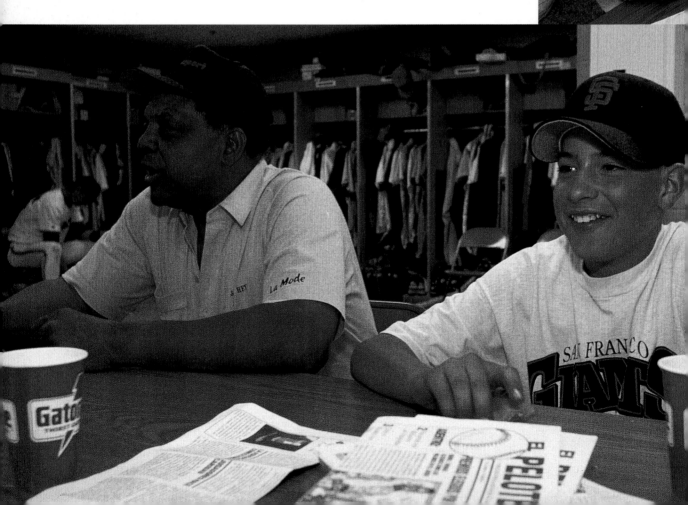

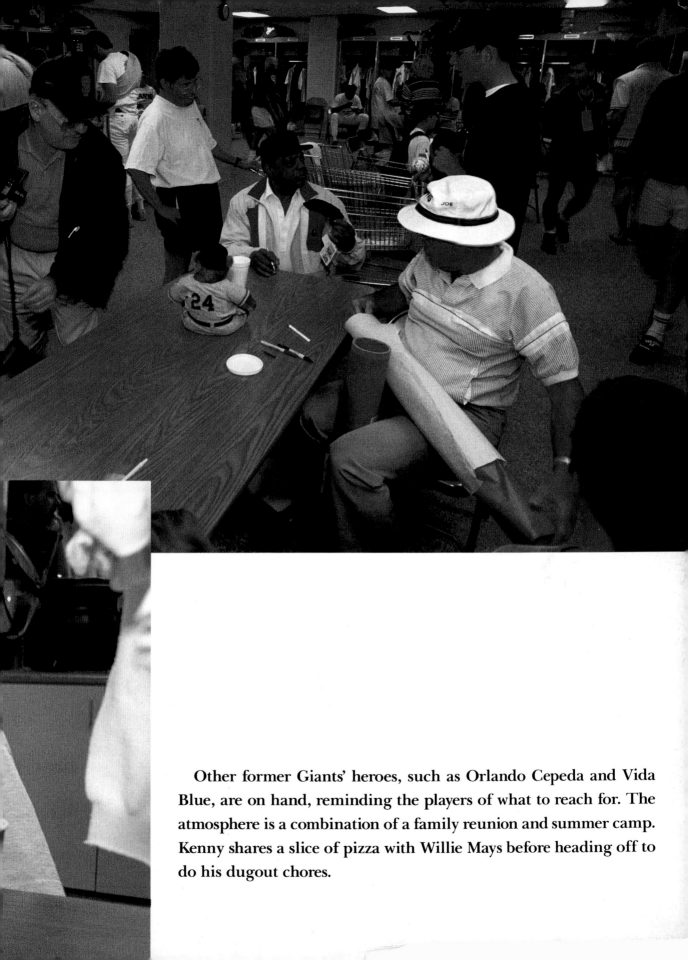

Other former Giants' heroes, such as Orlando Cepeda and Vida Blue, are on hand, reminding the players of what to reach for. The atmosphere is a combination of a family reunion and summer camp. Kenny shares a slice of pizza with Willie Mays before heading off to do his dugout chores.

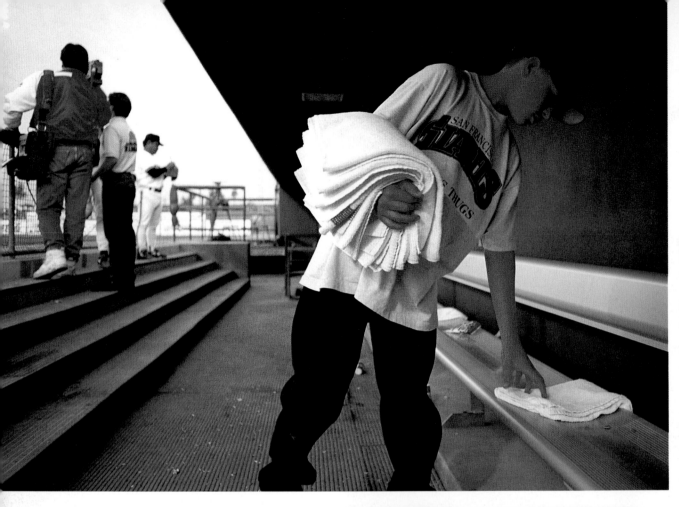

Clean towels and batting helmets must be in place before practice. Kenny then takes balls and other supplies to the visitors' dugout.

Aside from Kenny, the only ones on the field are the ground crews, who are hosing down the mound and raking the red-clay baselines.

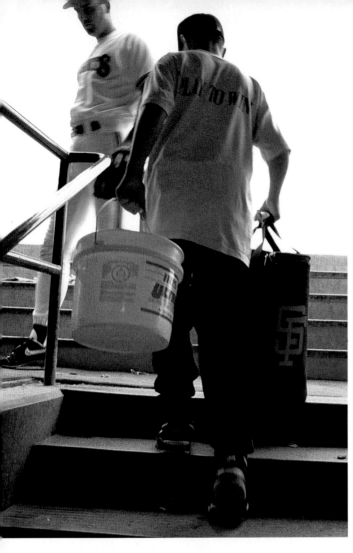

When early bird fans discover who Kenny is, they plead with him to get their favorite players' autographs. Kenny must be polite when he rejects their requests. Even *he* is not permitted to ask for an autograph. If he did, he would lose his job. The players must know that the people who work around them are there to make their lives easy and safe.

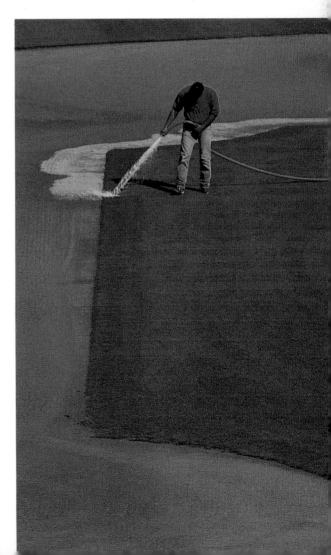

Around 10:30 A.M., the show begins with all its magic. Having had their team meeting with doctors, coaches, and managers, the players stampede out of the clubhouse into the light, and their public day begins.

They jog to the outfield beyond first base and form a circle around Coach Wendell Kim, whose raspy voice leads them through a series of conditioning exercises that are accompanied by the blare of stadium music.

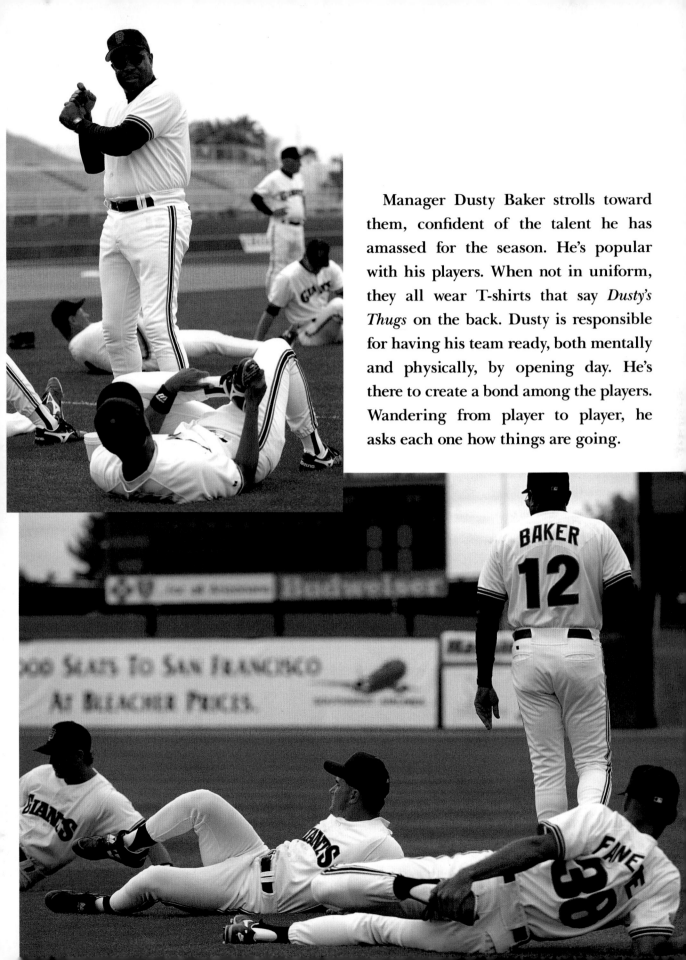

Manager Dusty Baker strolls toward them, confident of the talent he has amassed for the season. He's popular with his players. When not in uniform, they all wear T-shirts that say *Dusty's Thugs* on the back. Dusty is responsible for having his team ready, both mentally and physically, by opening day. He's there to create a bond among the players. Wandering from player to player, he asks each one how things are going.

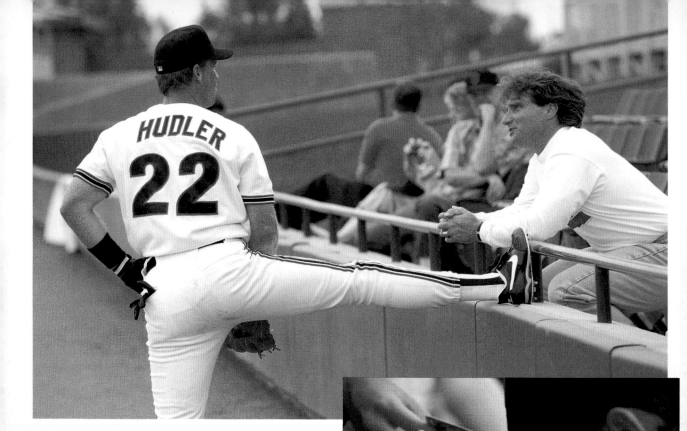

To play ball for a major-league organization means endless repetition. During spring training, as on every day of the regular season, the players will practice batting, run bases, have fielding drills, scoop up ground balls.

Out in the open the players are fair game to reporters and fans. That's part of their job as well.

The players who are still not sure of a spot on the team are more obliging to fans than the others. Rex Hudler, hoping for the job of utility infielder, stops to sign a ball for a youngster who could be Hudler's son. "Shall I sign the sweet spot?" he asks. "I'll do anything for a kid with freckles."

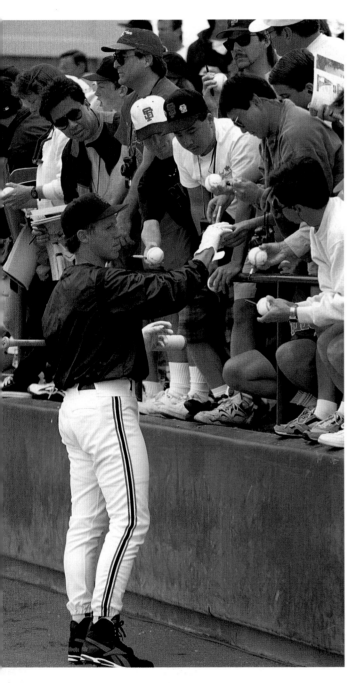

In contrast, Barry Bonds avoids the fans, preferring to humor his teammates and concentrate on perfecting his home-run hitting. He hits two over the fence in batting practice and goads Willie McGee into competition. "Don't think about it so much," Bonds says to McGee. "Just go in there and fire."

After more than an hour of practice, the Giants retreat to the locker room for lunch. Some players hide behind a book or newspaper while others let off steam with a game of cards.

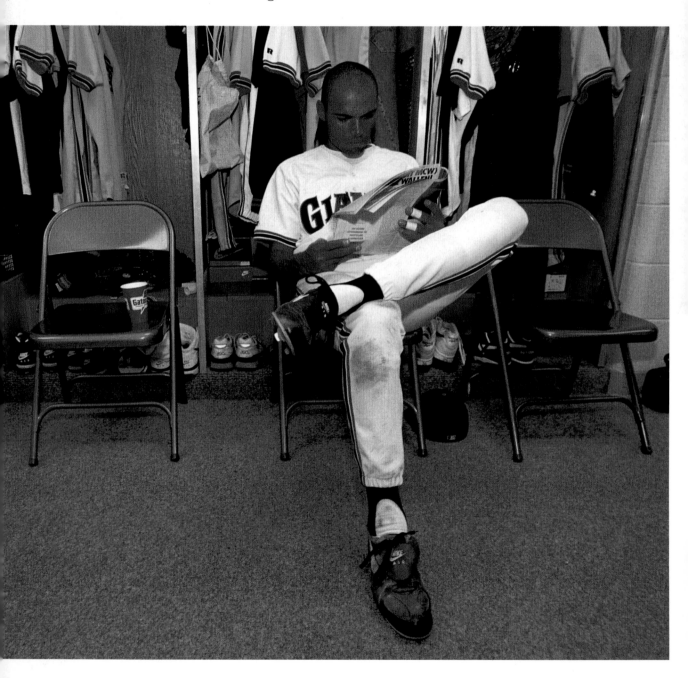

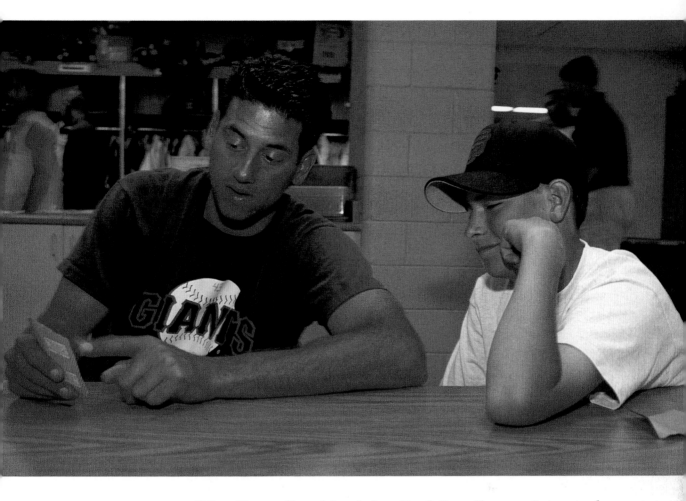

"Hey, Kenny," rookie pitcher Fred Costello says, "wanna play some cards?

"Batboys help relieve tension," says Costello. "I look at 'em and remember when I was a kid. They remind me of what the game is all about."

A former batboy with the Giants, Costello can hardly believe where he is. "The first day of camp I came in here real early to just sit and stare at my locker. When I was in the eighth grade, my best friend's father took over as visiting clubhouse manager at Candlestick Park. All the kids in the neighborhood got to be a batboy. My first day I took care of the Atlanta Braves. After watching the guys on TV, to see them in person was wild. It's something now to be a player."

And so the time dwindles away until game time—1:00 P.M. The Giants will play against the Kansas City Royals.

With eyes blackened to prevent glare from the harsh Arizona sun, the players take their seats in the dugout. A thirty-gallon container of Gatorade is in place along with the first-aid kit. The team's three doctors are also in the dugout, watching how the players' bodies are working during a game.

And then that sacred moment that occurs before every game: "Ladies and gentlemen, would you please rise for the national anthem." Kenny hops up, off the seat he has tucked neatly in the corner beside the bat box, hat over heart, and stands beside the team.

He then dashes to put the rosin bag, pine tar, and towels needed by each batter for warm-up at the on-deck circle, and runs back into the dugout as the umpire yells: "Play ball!"

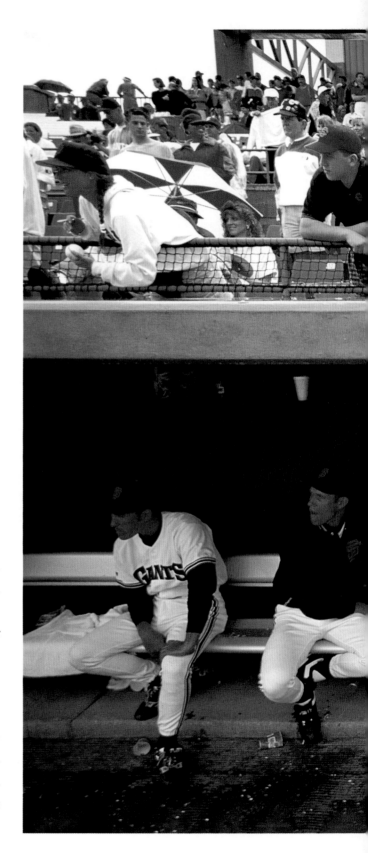

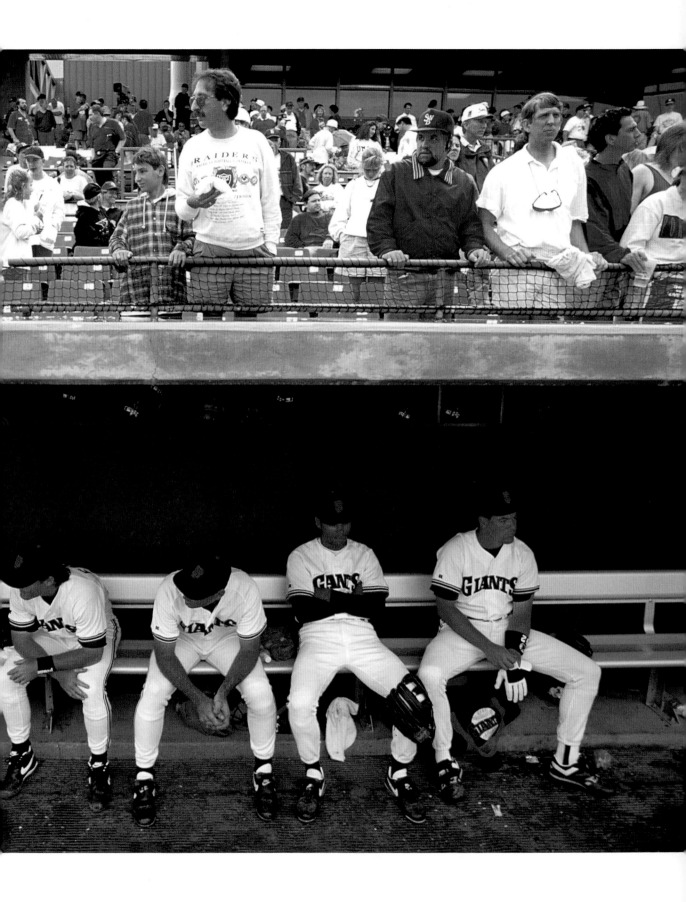

Kenny is all concentration. He must stay with the action. Sitting beside the coach and Dusty Baker, he can take in their comments amid the grunts a pitcher makes as he winds up and throws the ball.

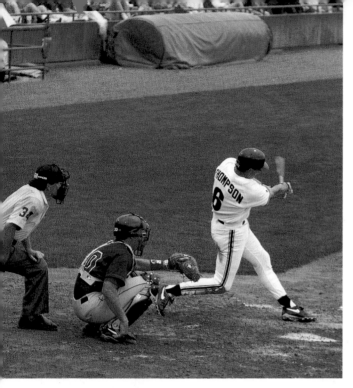

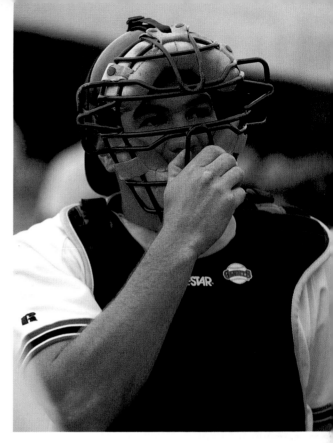

The peace of just sitting and watching doesn't last long. Suddenly infielder Robby Thompson wants more rosin, to get a better grip on his bat. Barry Bonds tosses Kenny a trinket that Bonds wants him to put in his locker. The umpire signals that he needs more balls. The home plate gets muddy after a brief sprinkle, and he needs to mop it off. Kirt Manwaring throws off his face mask as he runs to catch a foul ball, and Kenny must retrieve it. After striking out, a tense batter throws his helmet and bat, which Kenny must pick up between plays.

During all this he remains inconspicuous, and yet his swift darting in and out keeps the rhythm of the game flowing.

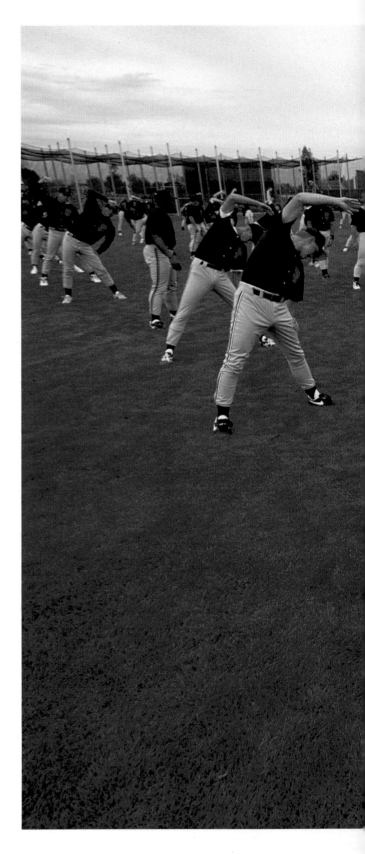

A professional makes playing ball look easy. But Kenny has observed the regimen these players endure from the minute they arrived in Arizona. He and Murph have been hauling equipment to the practice site down the street, where the Giants' organization maintains four warm-up diamonds. There are one hundred and thirty minor leaguers who make up their farm teams. "These reserves are the backbone of any major-league organization," explains one coach. "The lucky ones will work their way from single A to double A and finally triple A. From triple A, they can be drafted onto a major-league team."

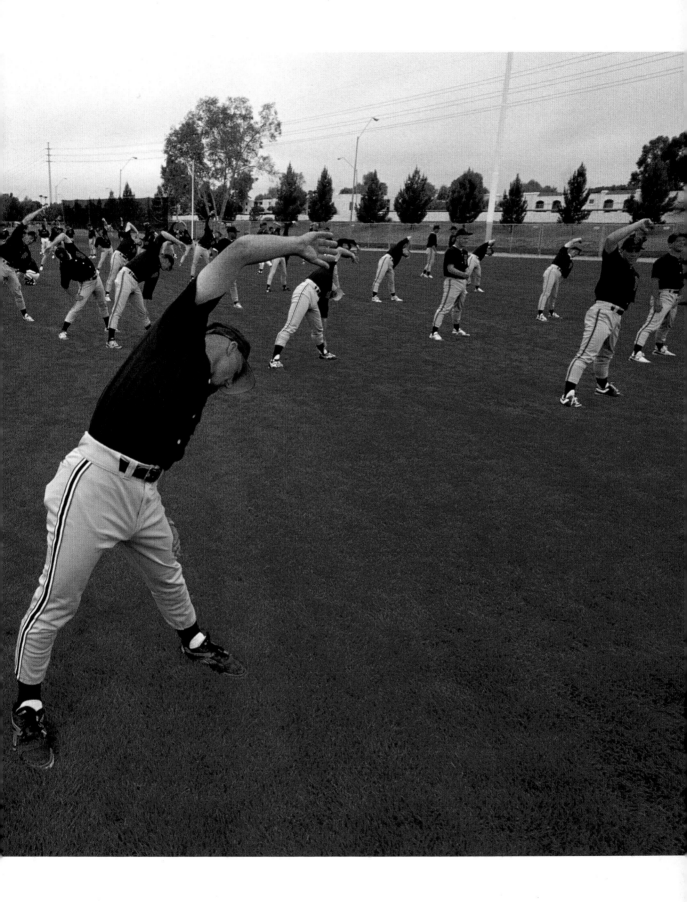

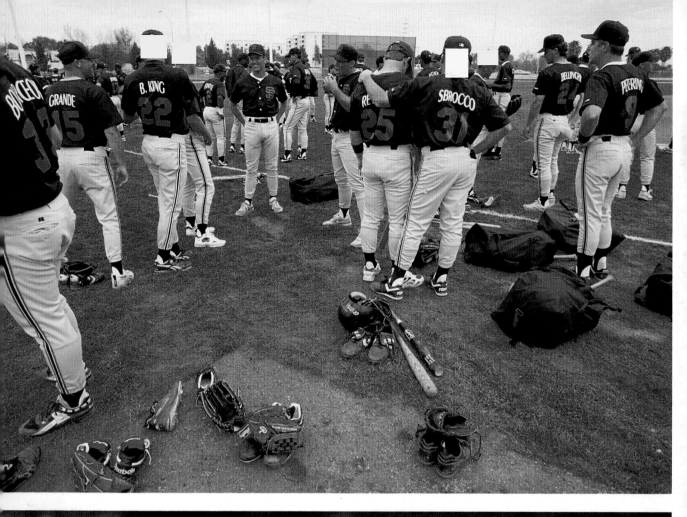

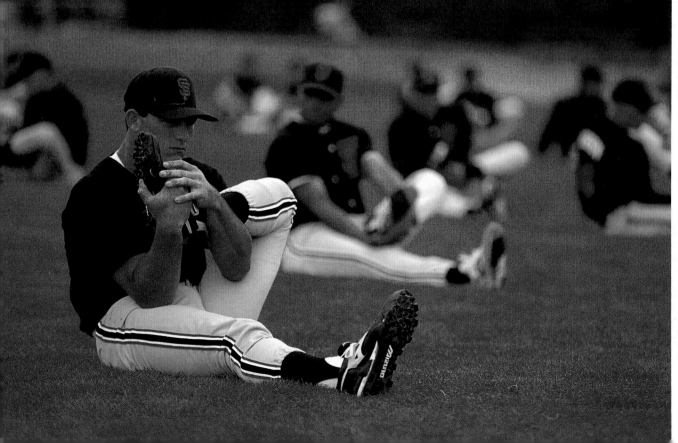

These farm-team players spend six weeks bashing hundreds of balls a day, running miles, working with weights, trying to make an impression on the coaches and scouts. Every move, every turn at bat, they must prove that they have what it takes: confidence, discipline, resilience, strength, good timing, a good eye, and most of all—desire.

From eight in the morning until two in the afternoon the lush green fields are speckled with the fast-moving orange-and-black uniforms as the players hit balls, work plays, pitch, and catch.

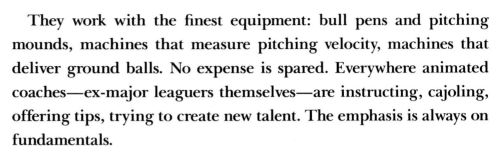

They work with the finest equipment: bull pens and pitching mounds, machines that measure pitching velocity, machines that deliver ground balls. No expense is spared. Everywhere animated coaches—ex-major leaguers themselves—are instructing, cajoling, offering tips, trying to create new talent. The emphasis is always on fundamentals.

"These kids come out of high school with a lot of bad habits," says one coach. "We've got to break them of these while developing their potential. We're looking for diamonds in the rough," he continues. "Most of these kids will look completely different when spring training is over."

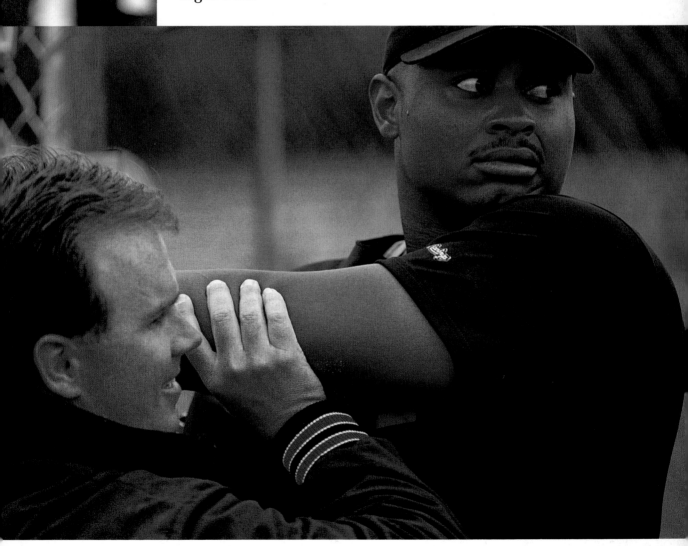

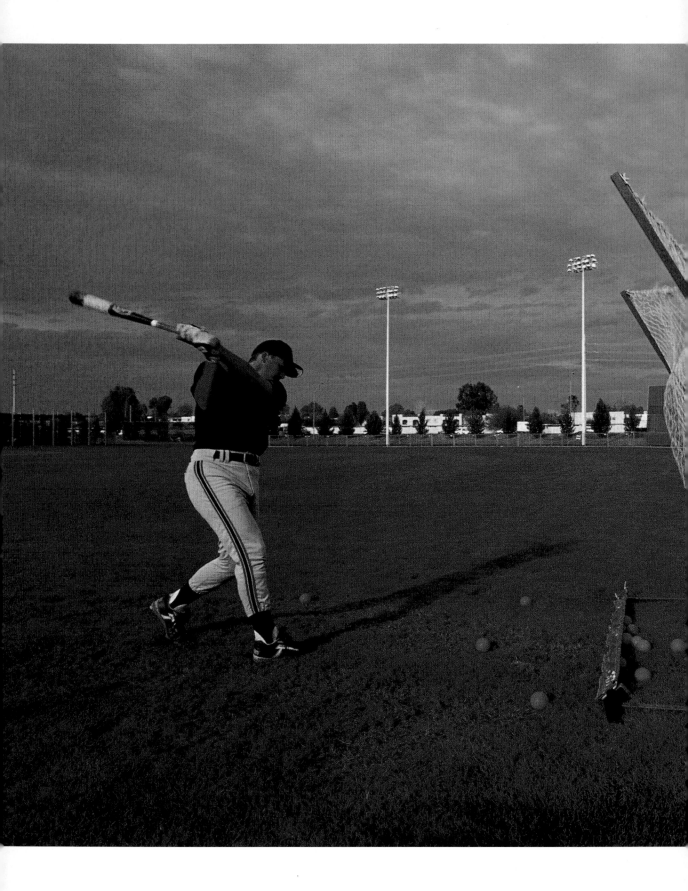

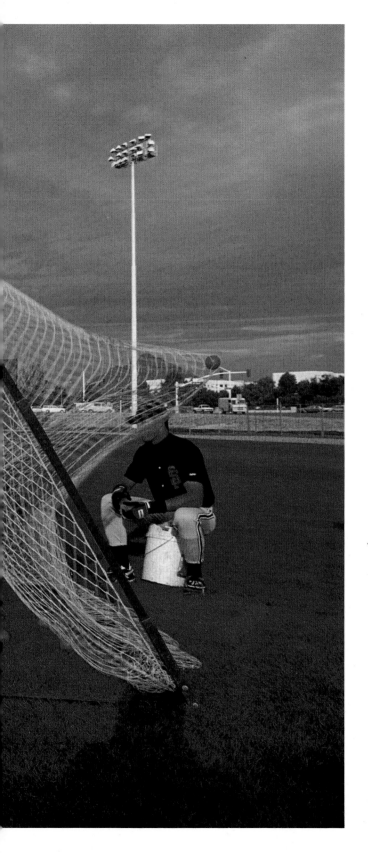

For others, it will be the end of a dream. "We've got to cut twenty or thirty," another coach explains. "Just like they are doing up the street in the big stadium. Being invited to spring training does not guarantee anyone a job."

But the players have been trained in losing, as well. "A big part of being successful in baseball is learning how to deal with failure," says one minor leaguer. "You're not going to hit every pitch or catch every ball. That's why we have one hundred and sixty-two games. The goal is to step up your game and not worry about the next guy."

That night, up the road at the Scottsdale Stadium, more drama is about to be played out.

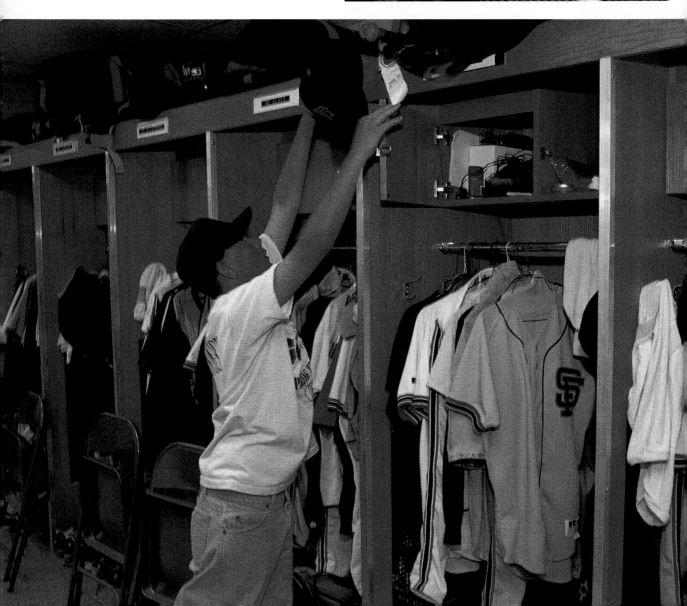

"Dusty just called," Murph says to Kenny. "He's bringing up four boys from the minors to try 'em out under the lights. We need to suit 'em up."

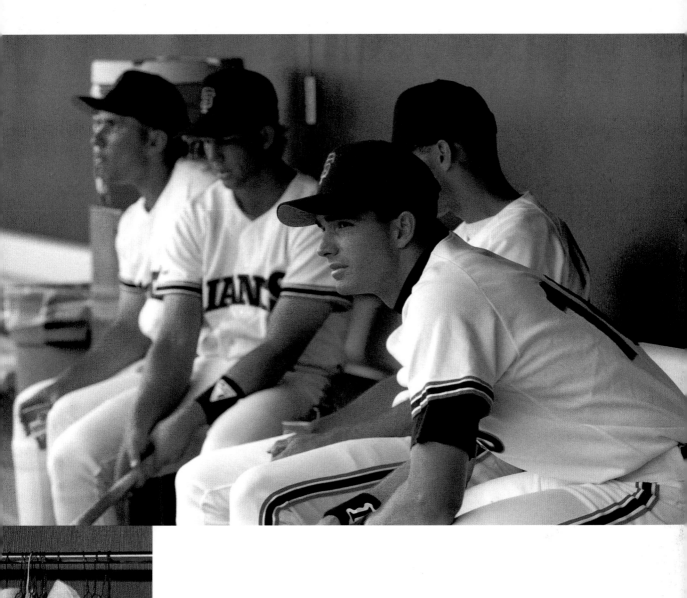

Kenny scrambles to get together all the paraphernalia in the correct sizes and have it ready beside four empty lockers. The new players will have shirts without names, which is how they will be distinguished from the players on the roster.

The minor leaguers go up to the dugout, dazed but excited. Their job will be to pinch-hit or run bases for one of the regulars. It will be hard for them to concentrate on the game while sitting next to their heroes.

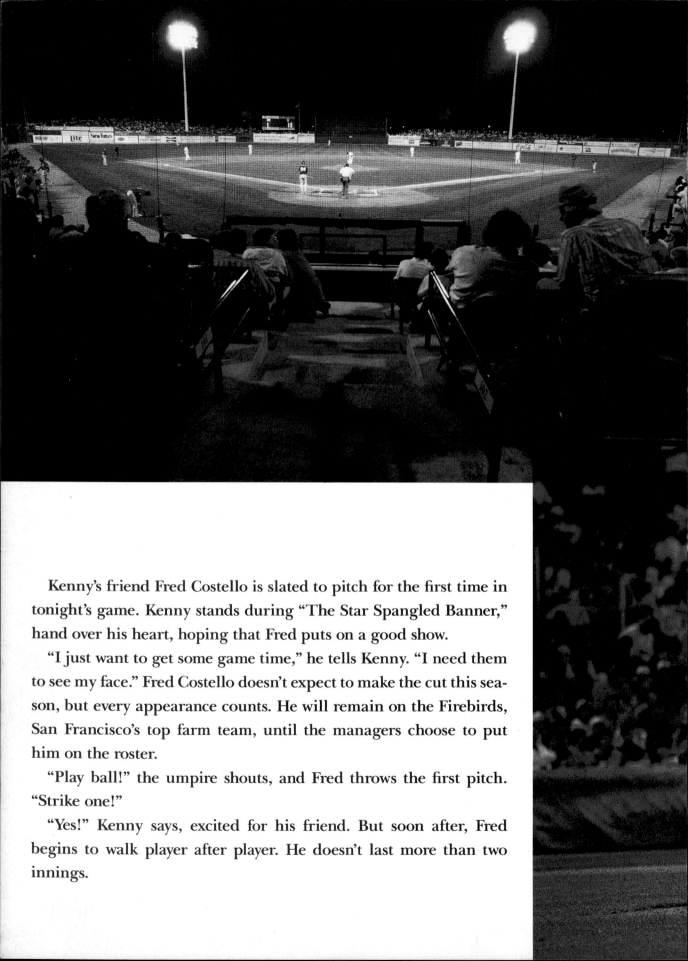

Kenny's friend Fred Costello is slated to pitch for the first time in tonight's game. Kenny stands during "The Star Spangled Banner," hand over his heart, hoping that Fred puts on a good show.

"I just want to get some game time," he tells Kenny. "I need them to see my face." Fred Costello doesn't expect to make the cut this season, but every appearance counts. He will remain on the Firebirds, San Francisco's top farm team, until the managers choose to put him on the roster.

"Play ball!" the umpire shouts, and Fred throws the first pitch. "Strike one!"

"Yes!" Kenny says, excited for his friend. But soon after, Fred begins to walk player after player. He doesn't last more than two innings.

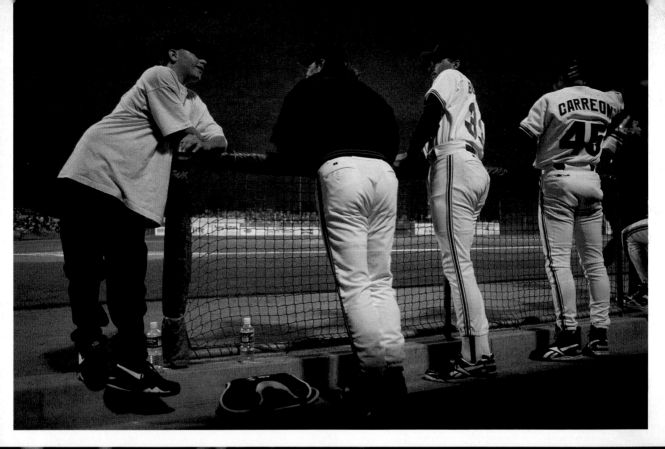
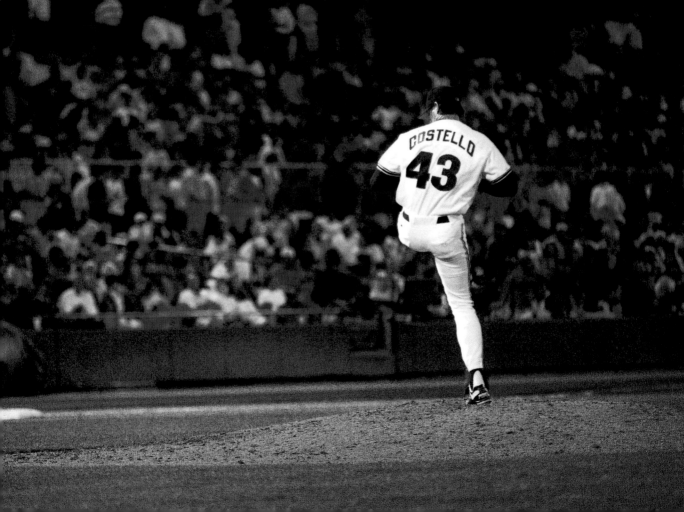

The Giants lose tonight's game, but they have played fifteen straight games, and no one seems to care about the loss. They need a couple of days off—and so does Kenny. He has missed several Babe Ruth practices and is heading into his next game cold.

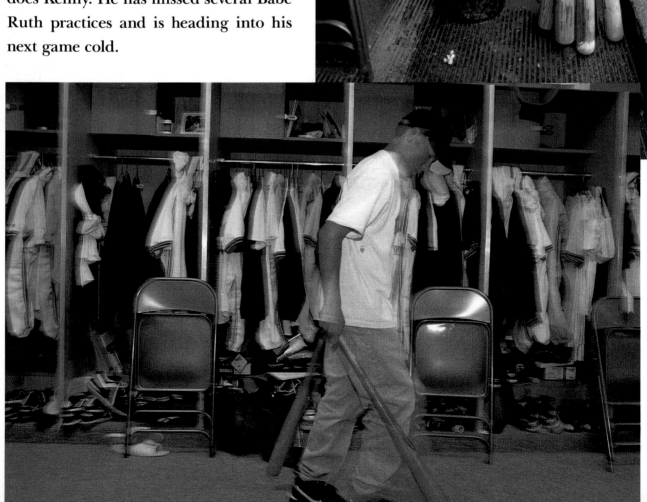

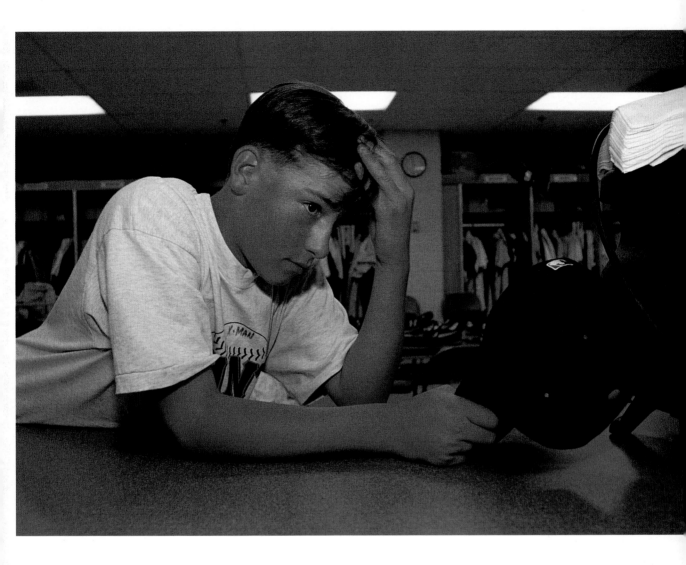

The hot and sweaty players hop into the shower, leaving their dirty clothes on the floor behind them. Pushing a laundry cart, Kenny scoops them up and heads for Pop.

"Keep workin', buddy," Murph says. "Could you fold up the dignitaries' chairs outside and check the dugout for towels?"

Even someone as eager and agreeable as Kenny is dragging. It's been a fourteen-hour day. He sure has earned his twenty-five dollars this time.

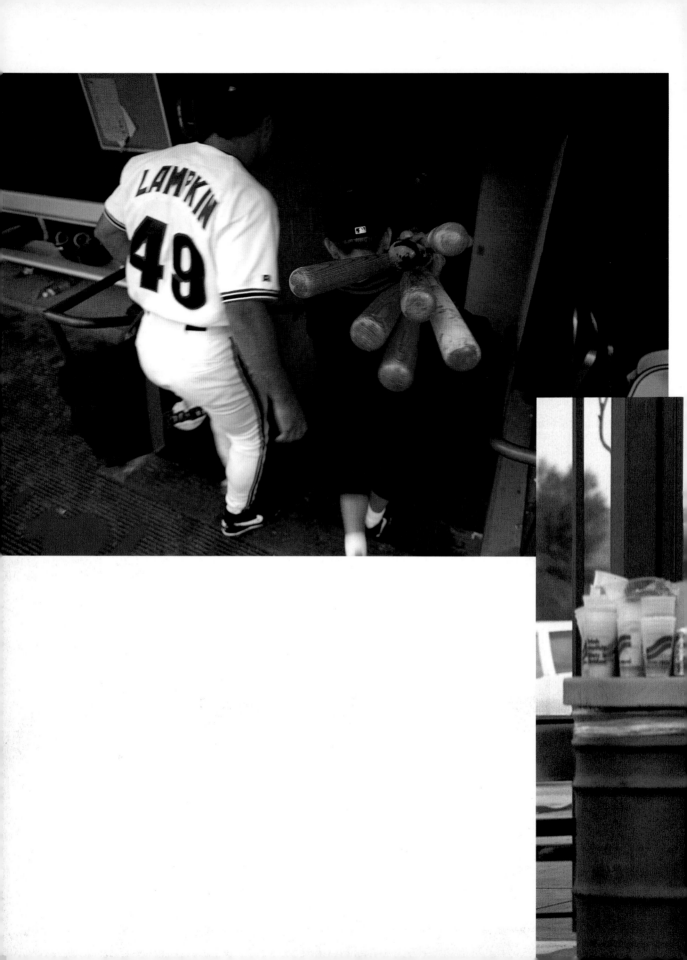

As tired as he gets, Kenny wouldn't trade places with anyone. Every day he sees something new. He can hardly believe that today he watched Bo Jackson play. "The guys that I work with teach me new stuff every day," Kenny says. "And in a couple of years I'll be old enough for a farm team myself."

For now he's anxious to get a good night's sleep so he'll be ready to play ball tomorrow. And after that? Well, he's just been hired to be the Phoenix Firebirds' batboy for the summer.

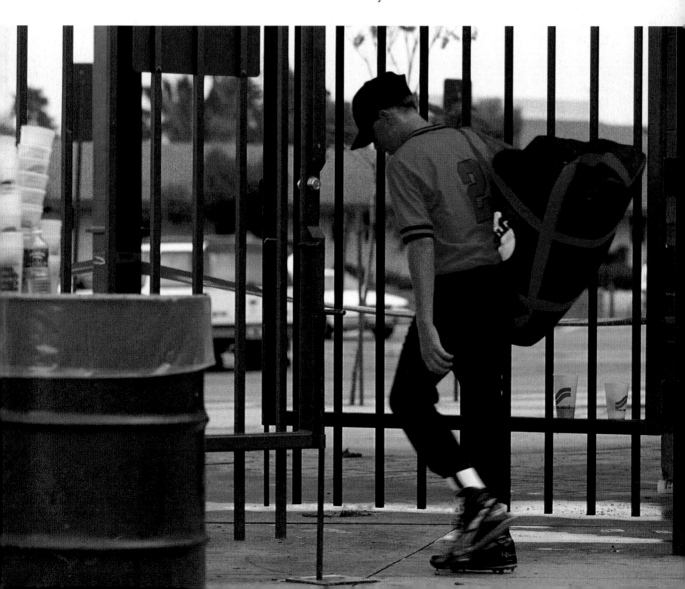

Glossary

Babe Ruth Baseball a youth league that is the next step after Little League

batter's box a marked spot around home plate where batter stands to hit

bat box a case in the dugout for the storage of bats during the game

bull pen a place on the field where relief pitchers warm up and wait to be summoned to play

doubleheader one major league game followed by another

dugout a long, narrow spot dug out of the field, usually under the stands, where players and coaches sit during the game

farm teams professional minor league affiliates in which players develop skills to play in the major leagues

fielding drills exercises in which players practice any kind of experience they might encounter during a game: ground balls, pop-ups, running and stealing bases, squeeze plays, etc.

pinch-hit to change the batting line-up and substitute one player for another

pine tar tree sap used on the bat for a better grip

pitching mound a carefully manicured, raised hump of dirt in the center of the diamond where the pitcher throws the ball to the batter

rosin bag a pouch containing rosin that is used by the player on his hands to get a better grip on the bat

single A, double A, triple A three minor league levels of baseball where players refine their skills and await being called up to a major league team

spring training roster a list of forty-three players who play in actual spring training games; the best twenty-five become members of the team.

utility infielder a team member who can play several field positions